This Book Belongs to _____

Copyrights @ Mommy's Art & Craft

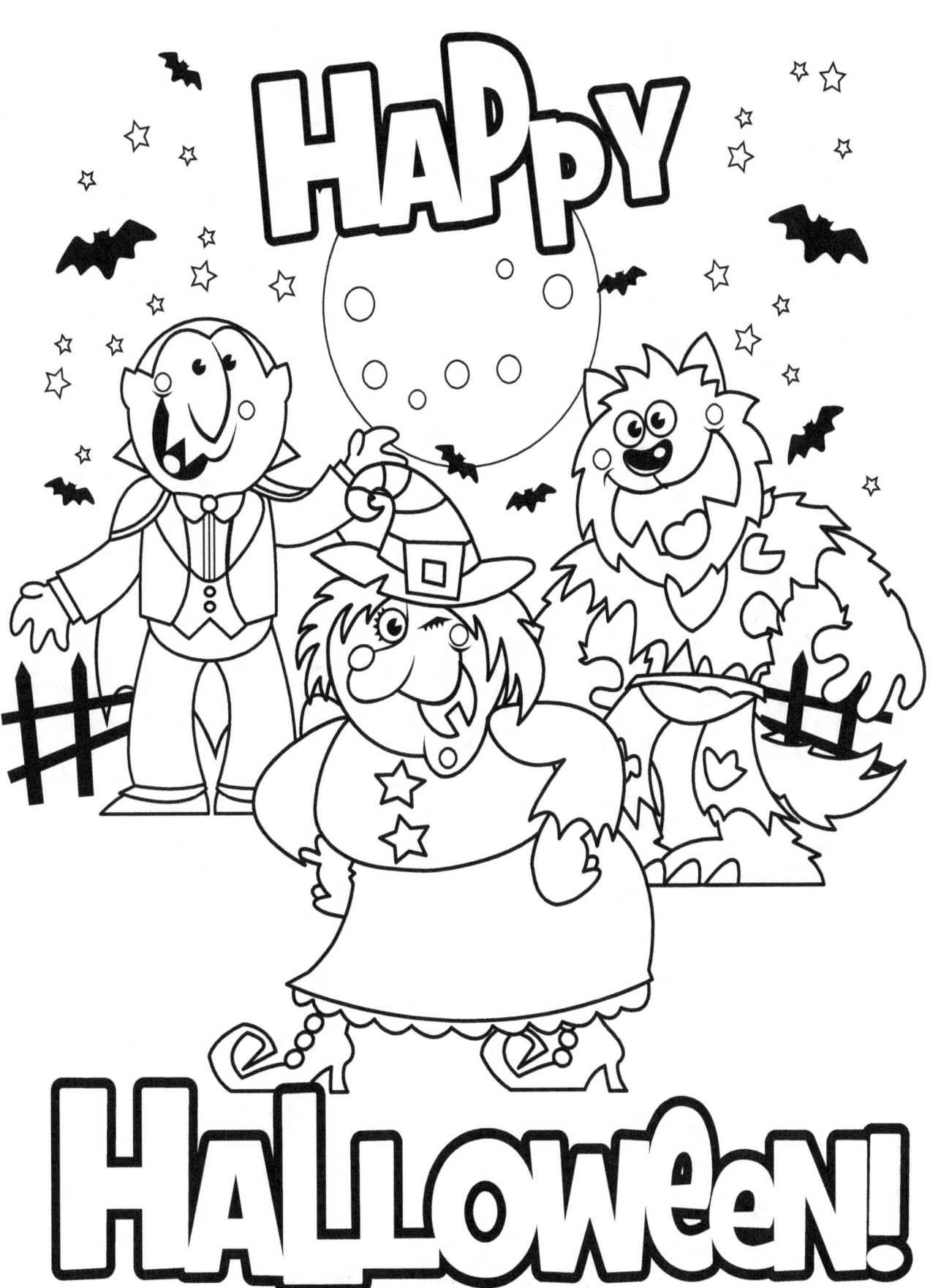

Copyrights @ Mommy's Art & Craft

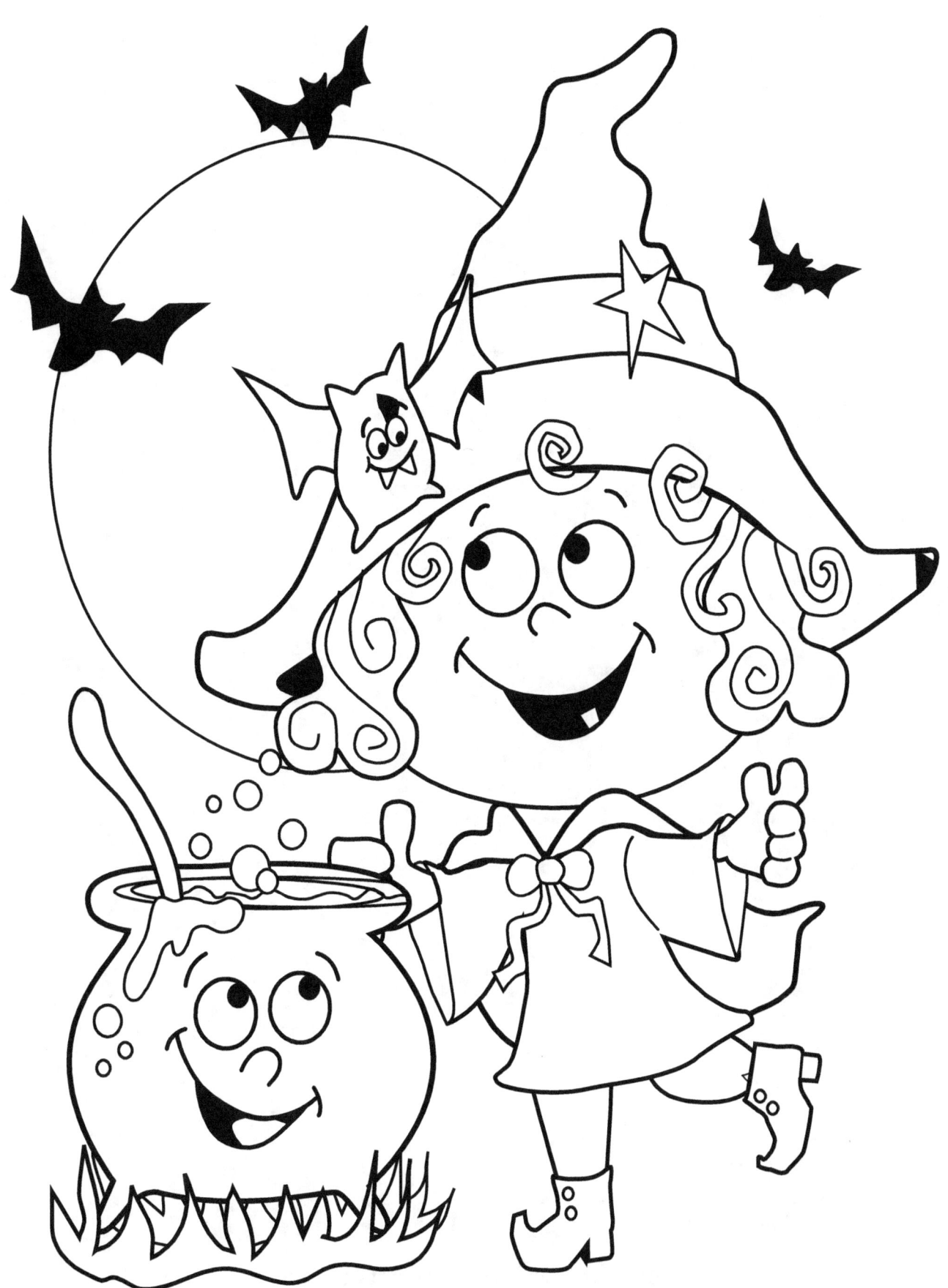

Copyrights @ Mommy's Art & Craft

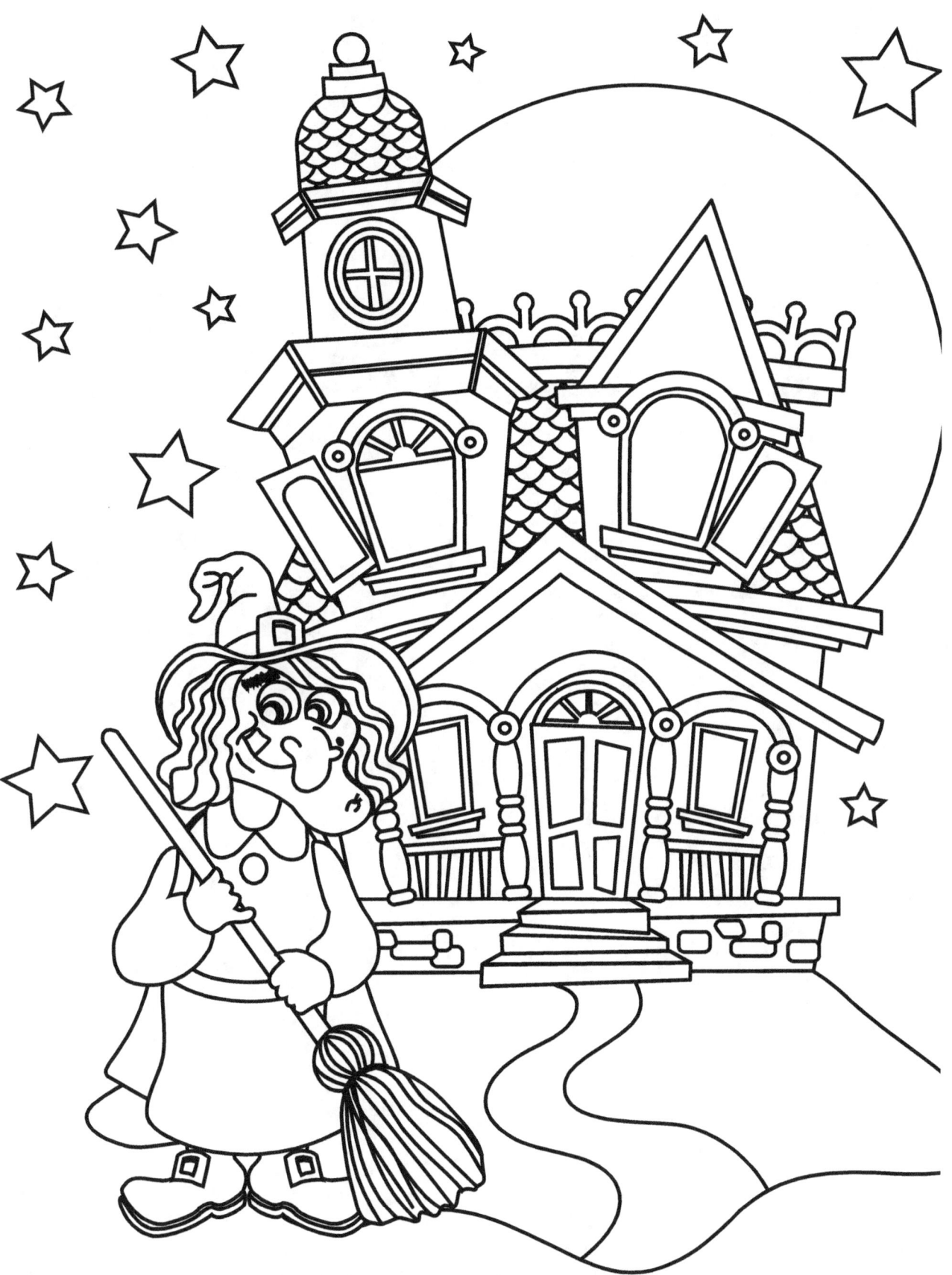

Copyrights @ Mommy's Art & Craft

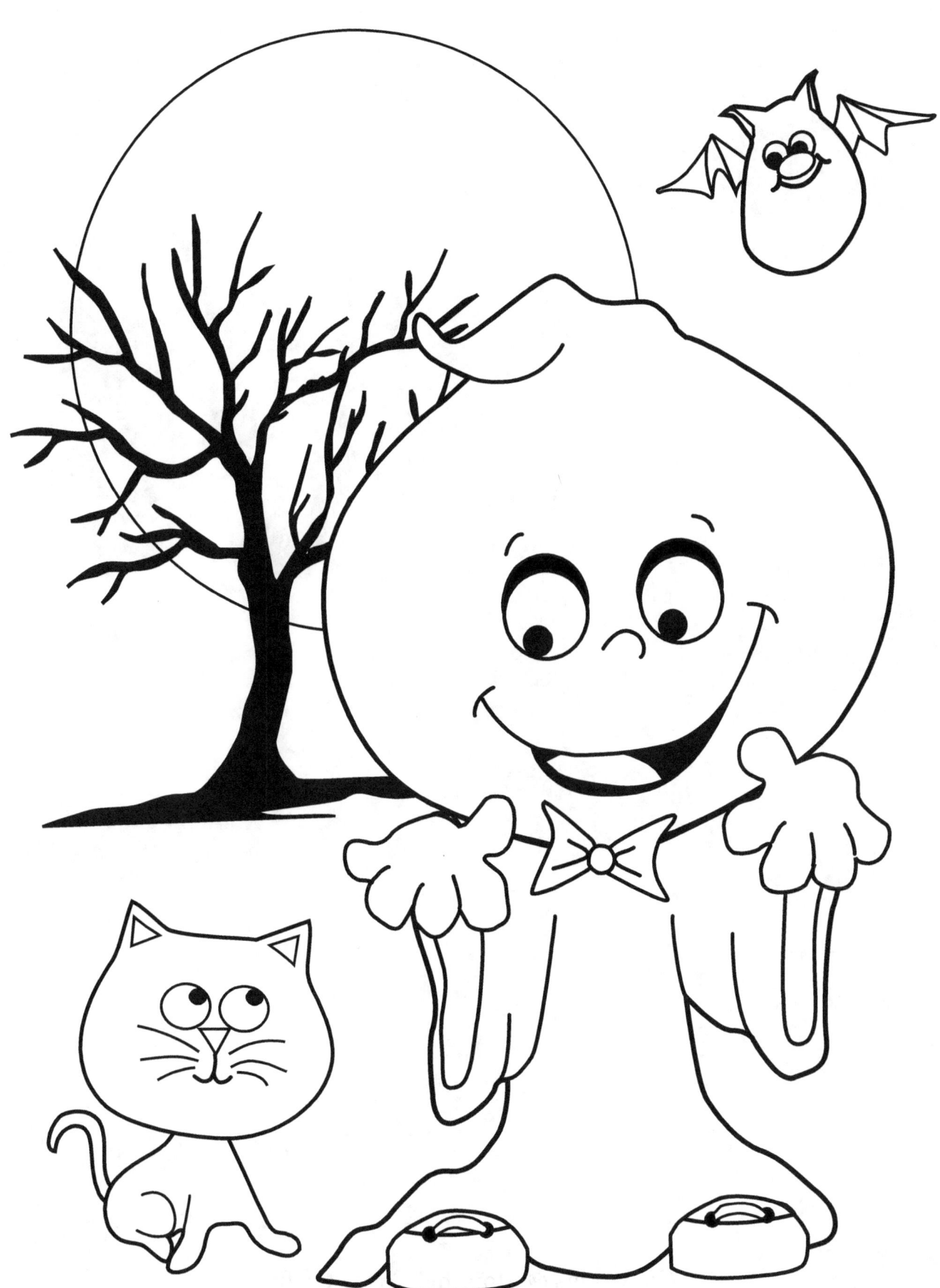

Copyrights @ Mommy's Art & Craft

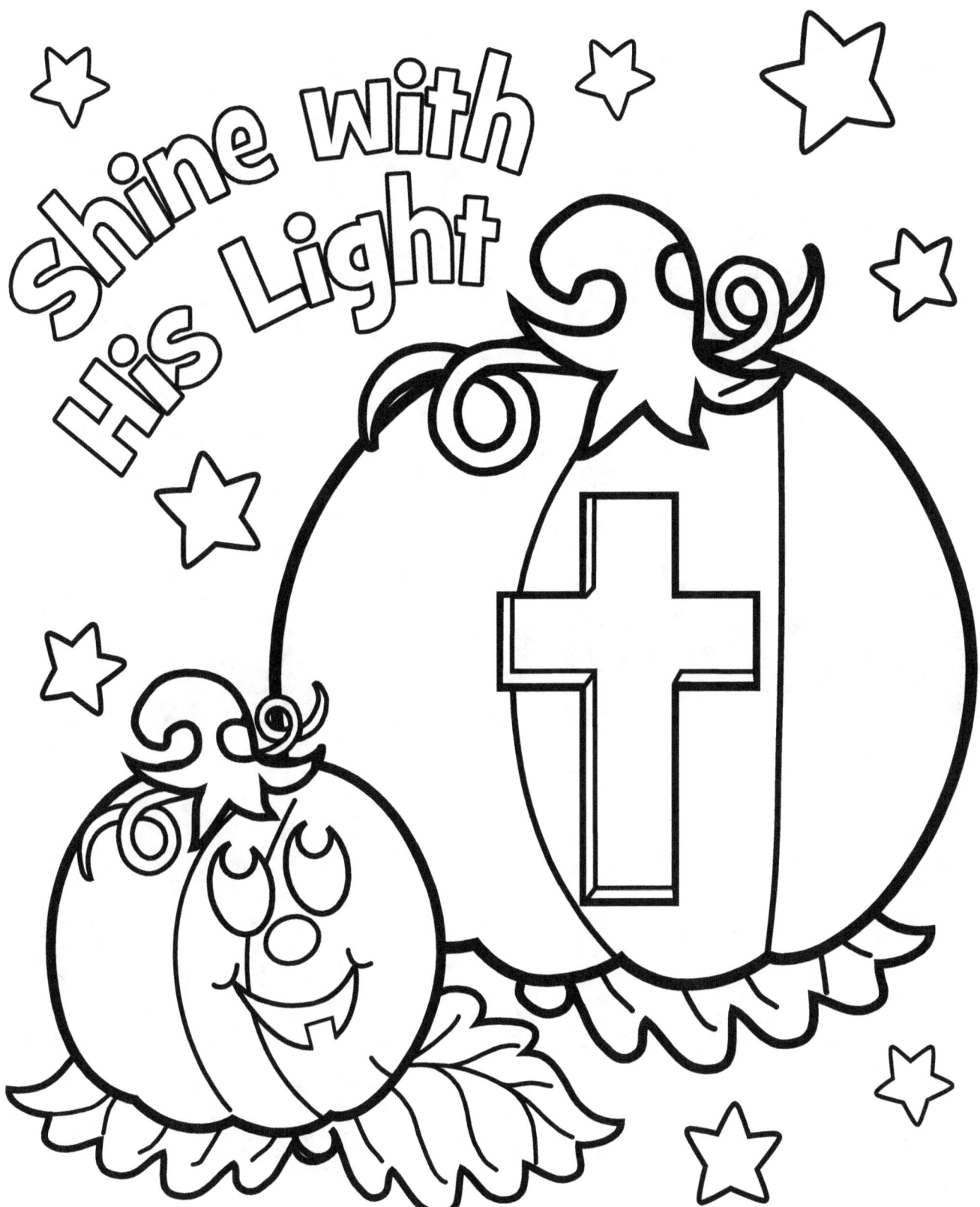

Copyrights @ Mommy's Art & Craft

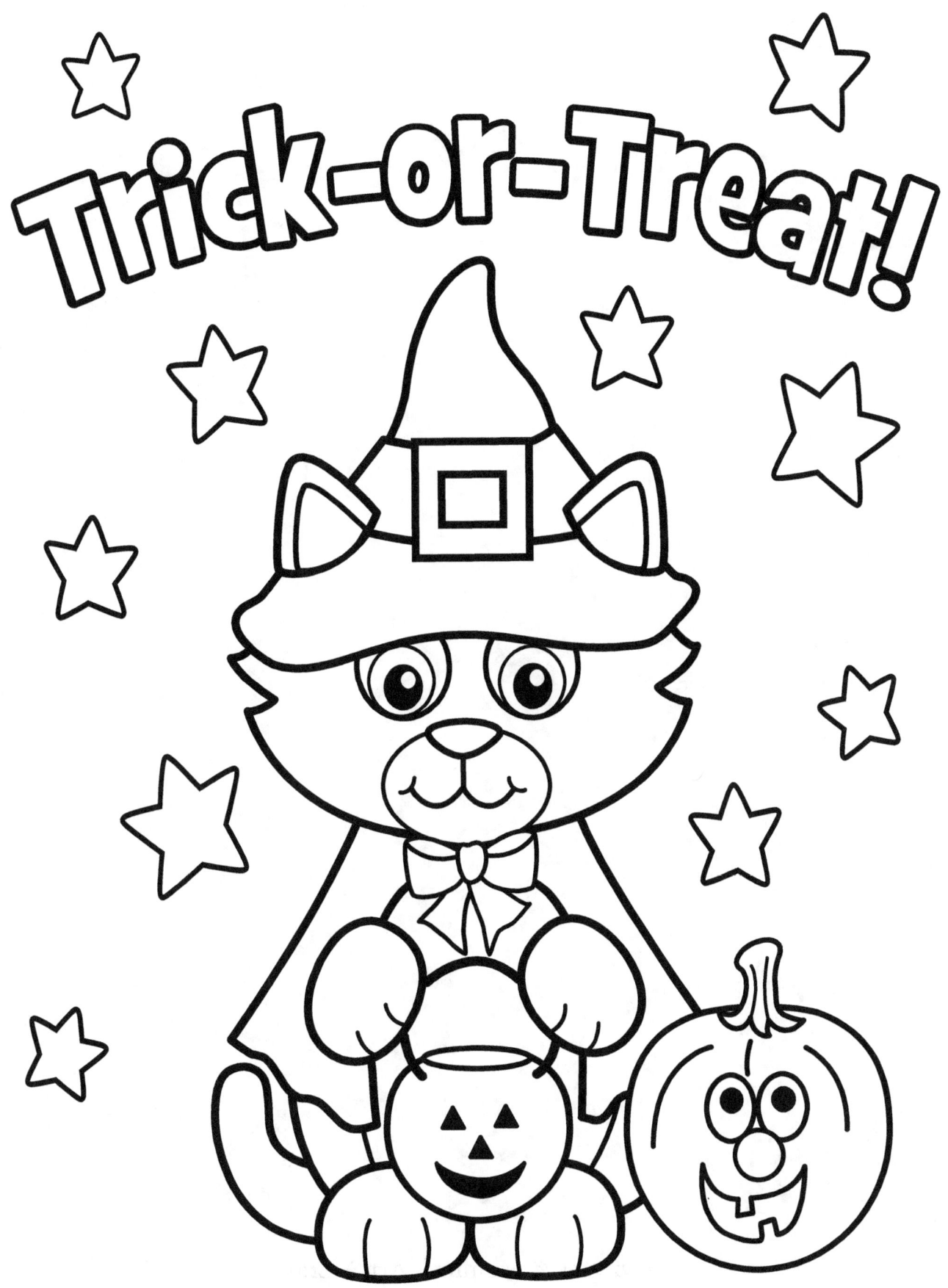

Copyrights @ Mommy's Art & Craft

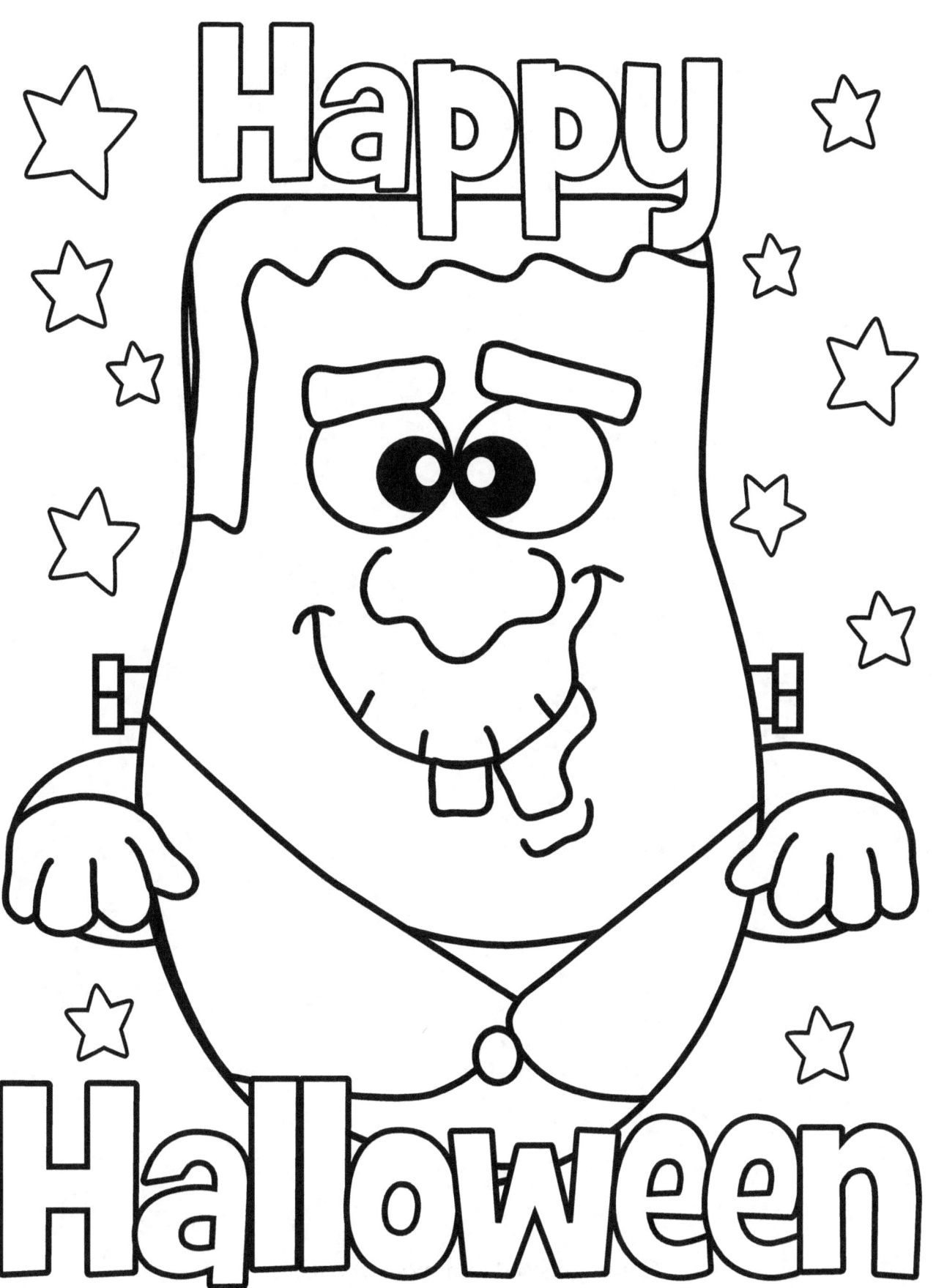

Copyrights @ Mommy's Art & Craft

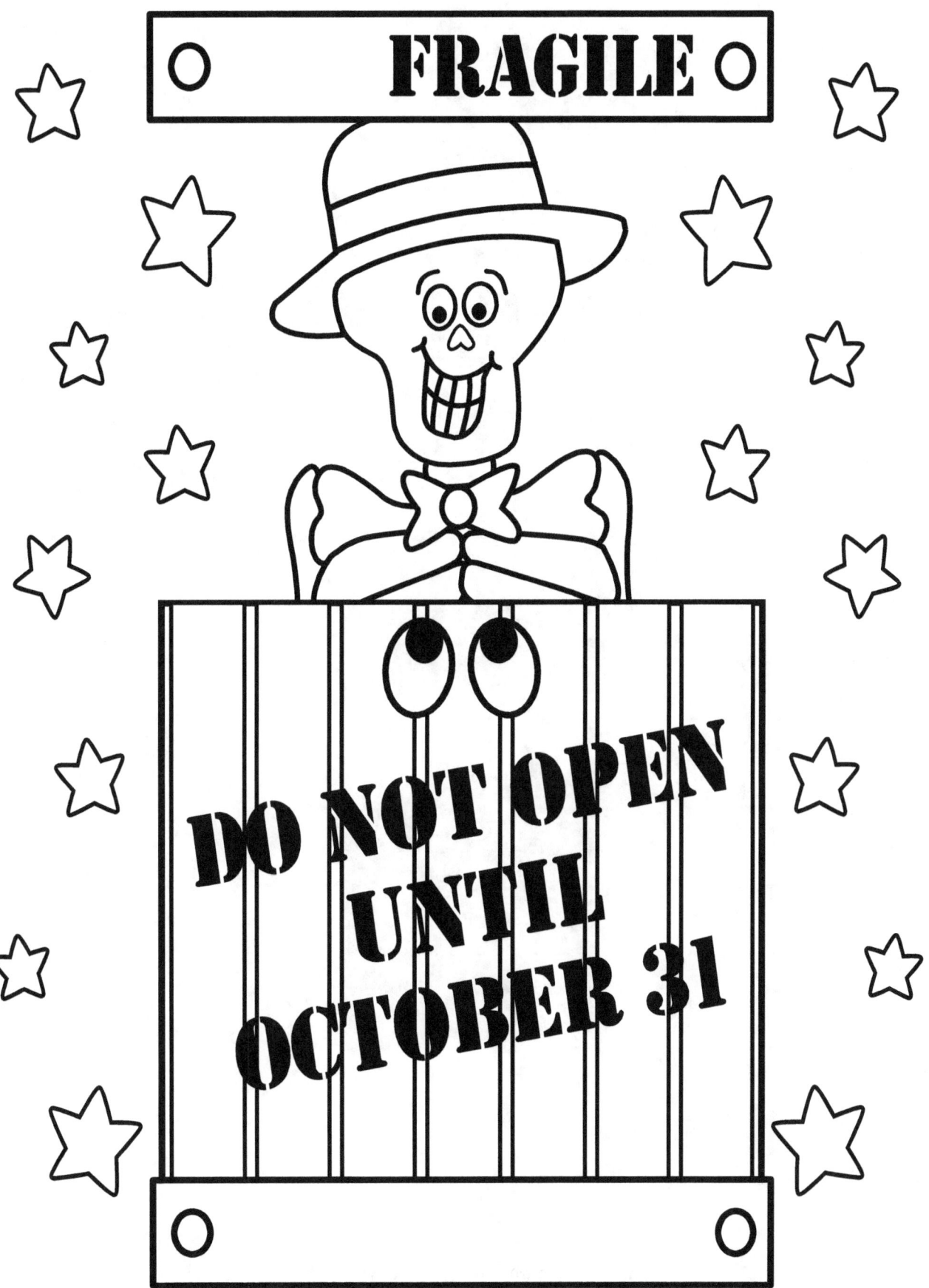

Copyrights @ Mommy's Art & Craft

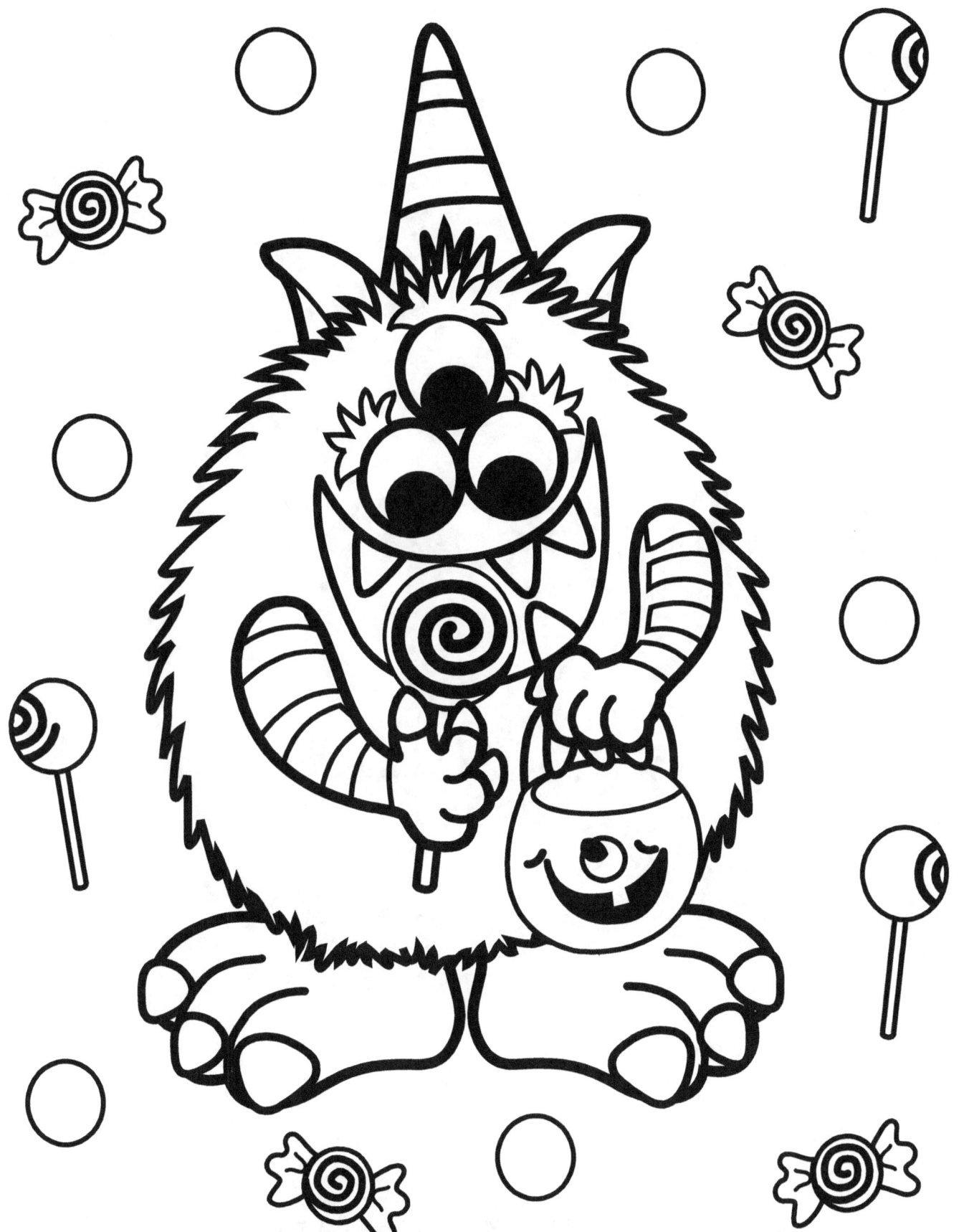

Copyrights @ Mommy's Art & Craft

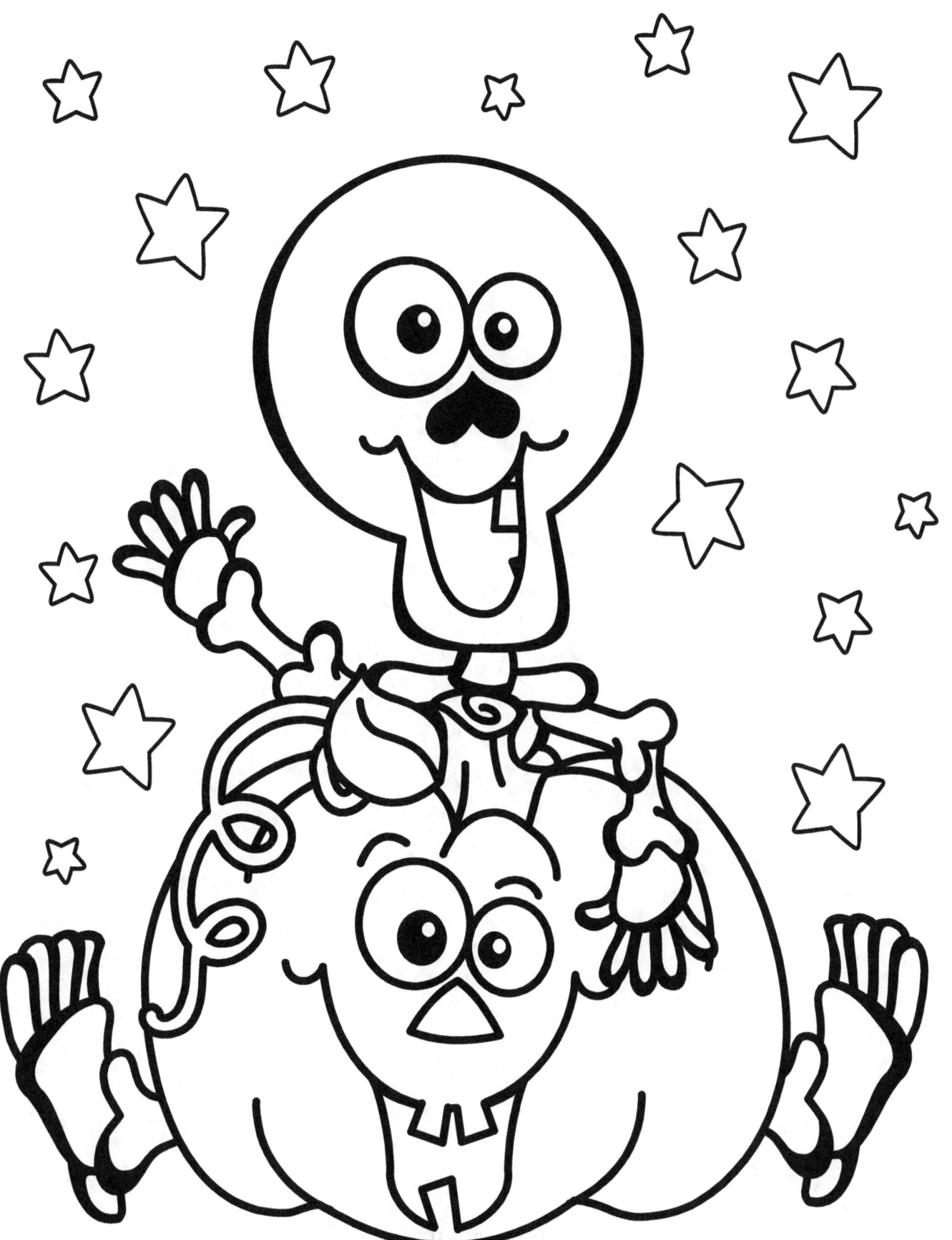

Copyrights @ Mommy's Art & Craft

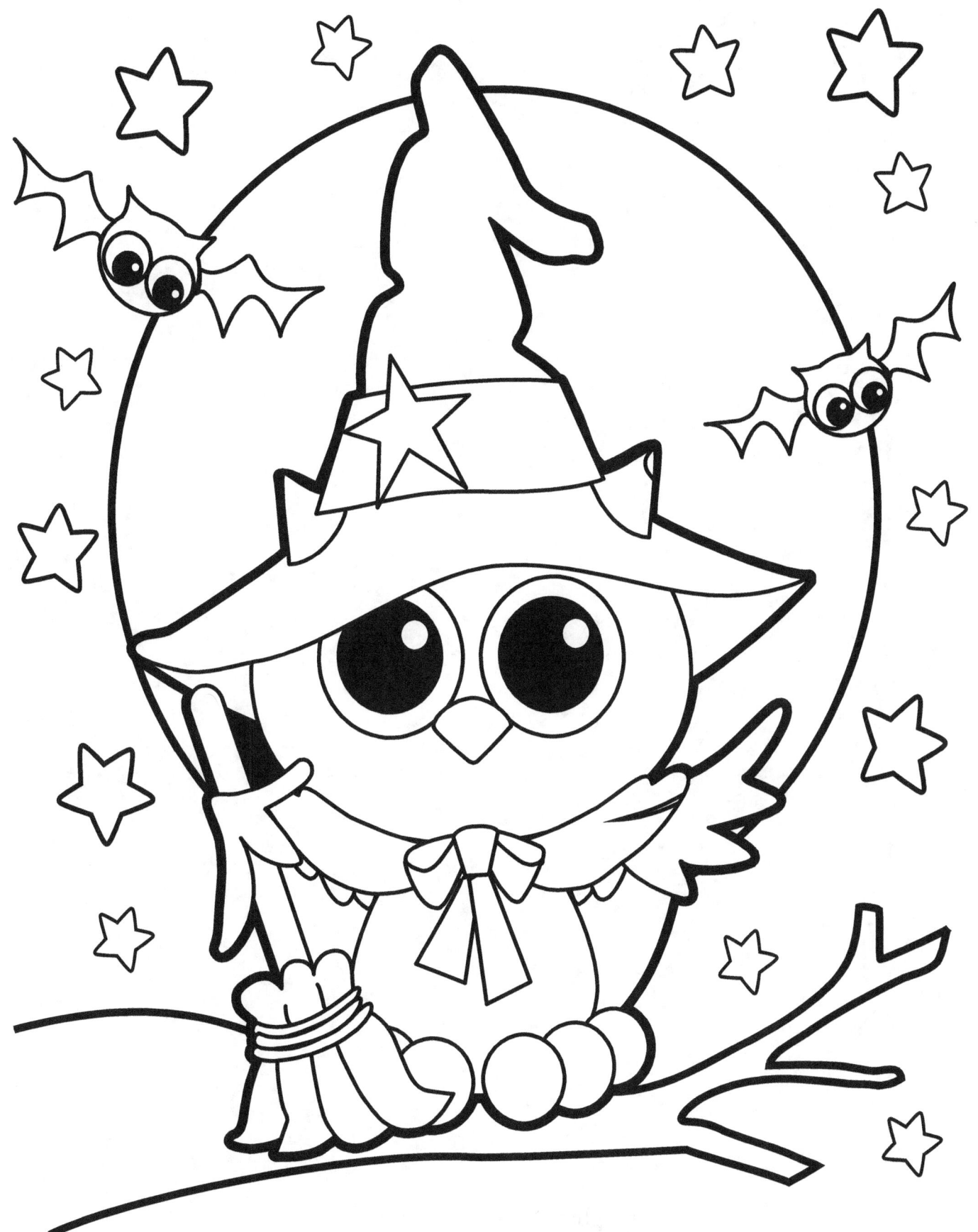

Copyrights @ Mommy's Art & Craft

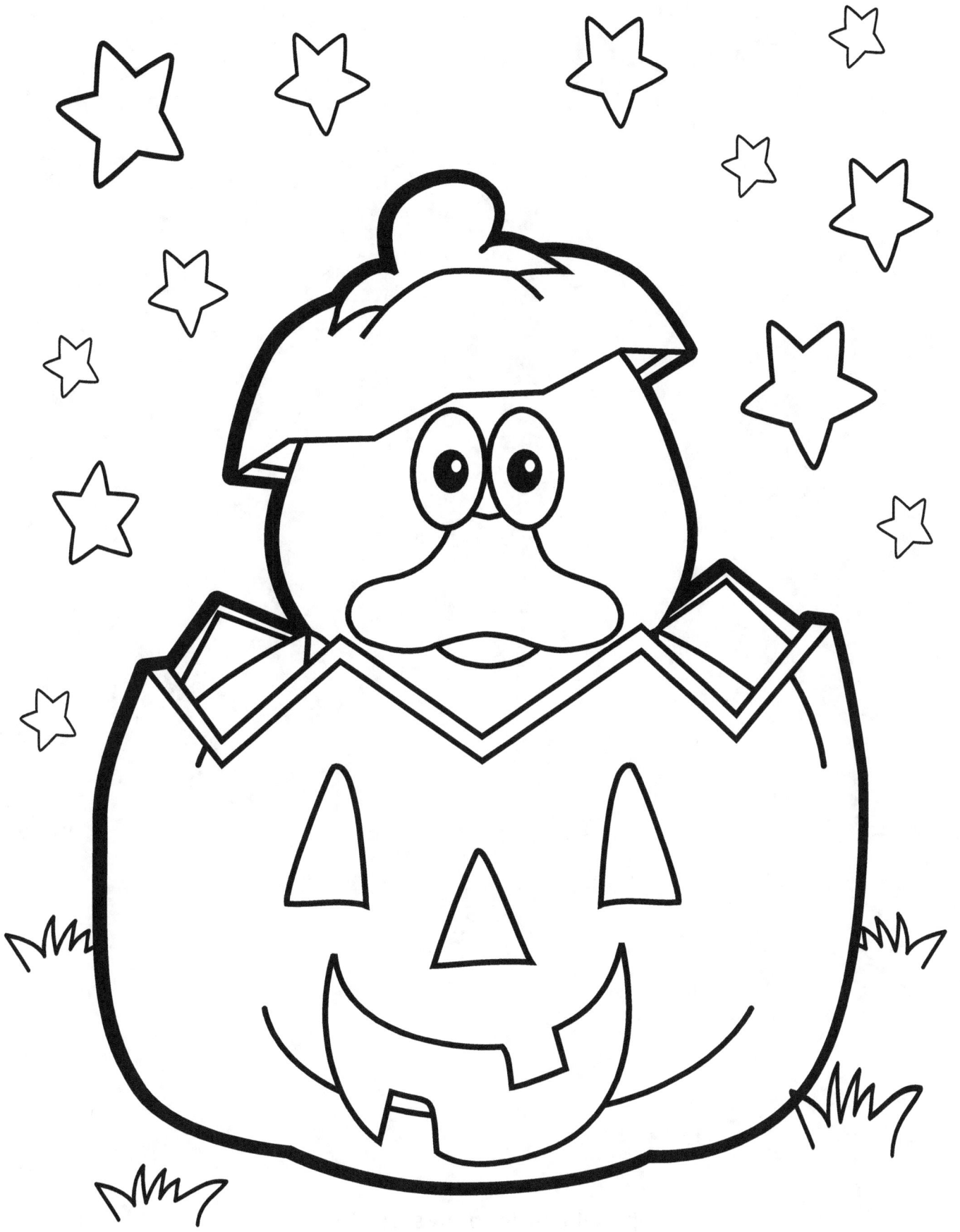

Copyrights @ Mommy's Art & Craft

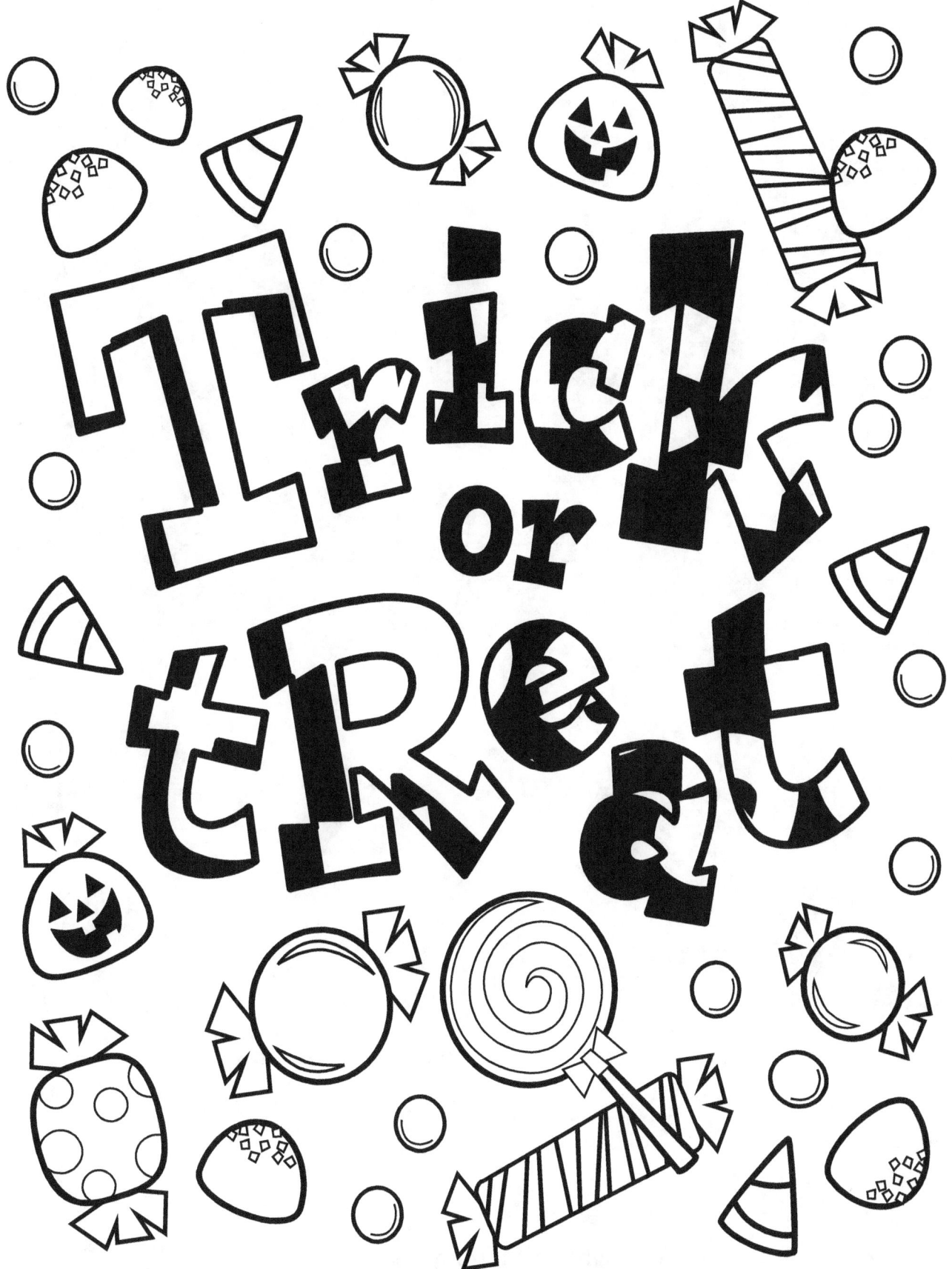

Copyrights @ Mommy's Art & Craft

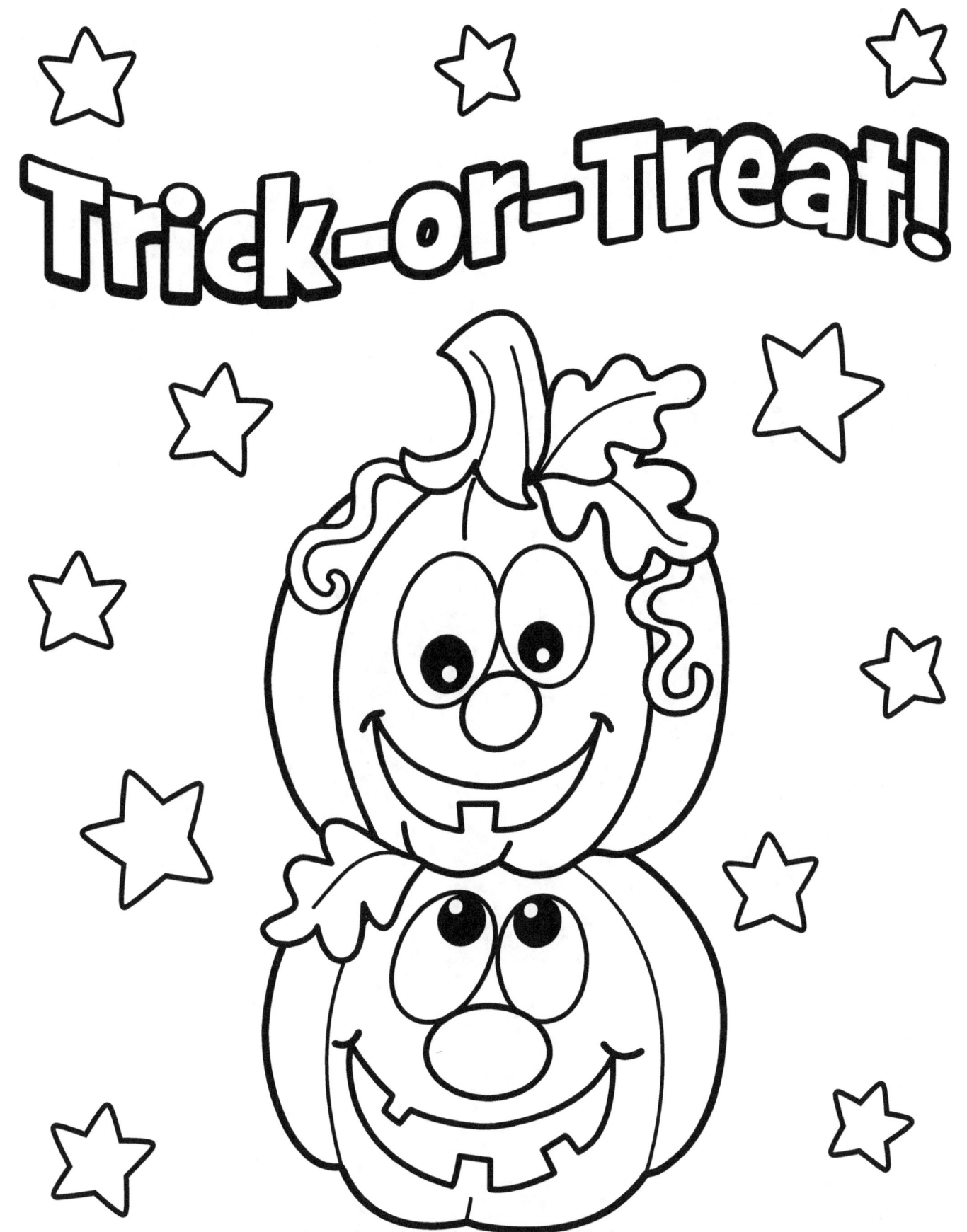

Copyrights @ Mommy's Art & Craft

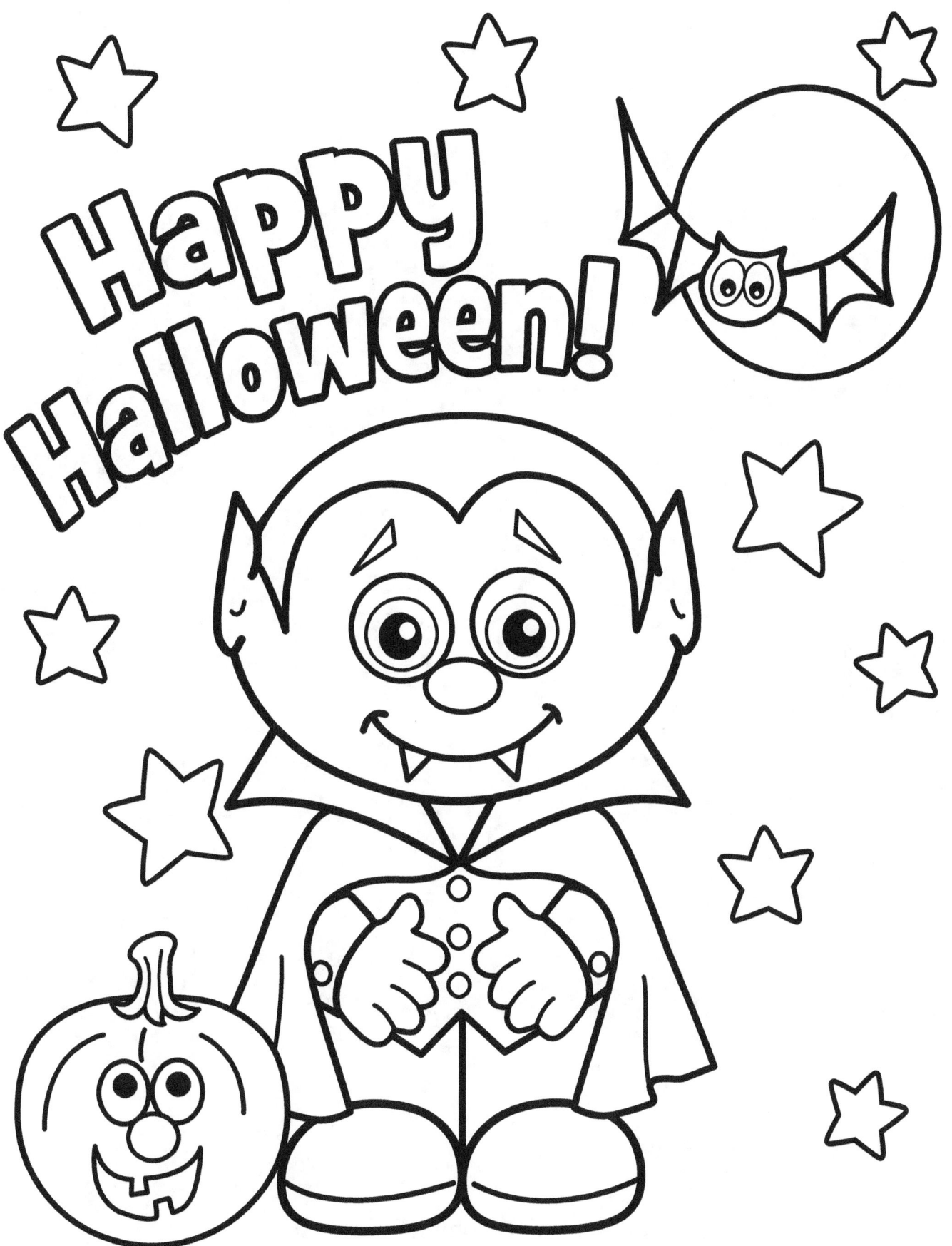

Copyrights @ Mommy's Art & Craft

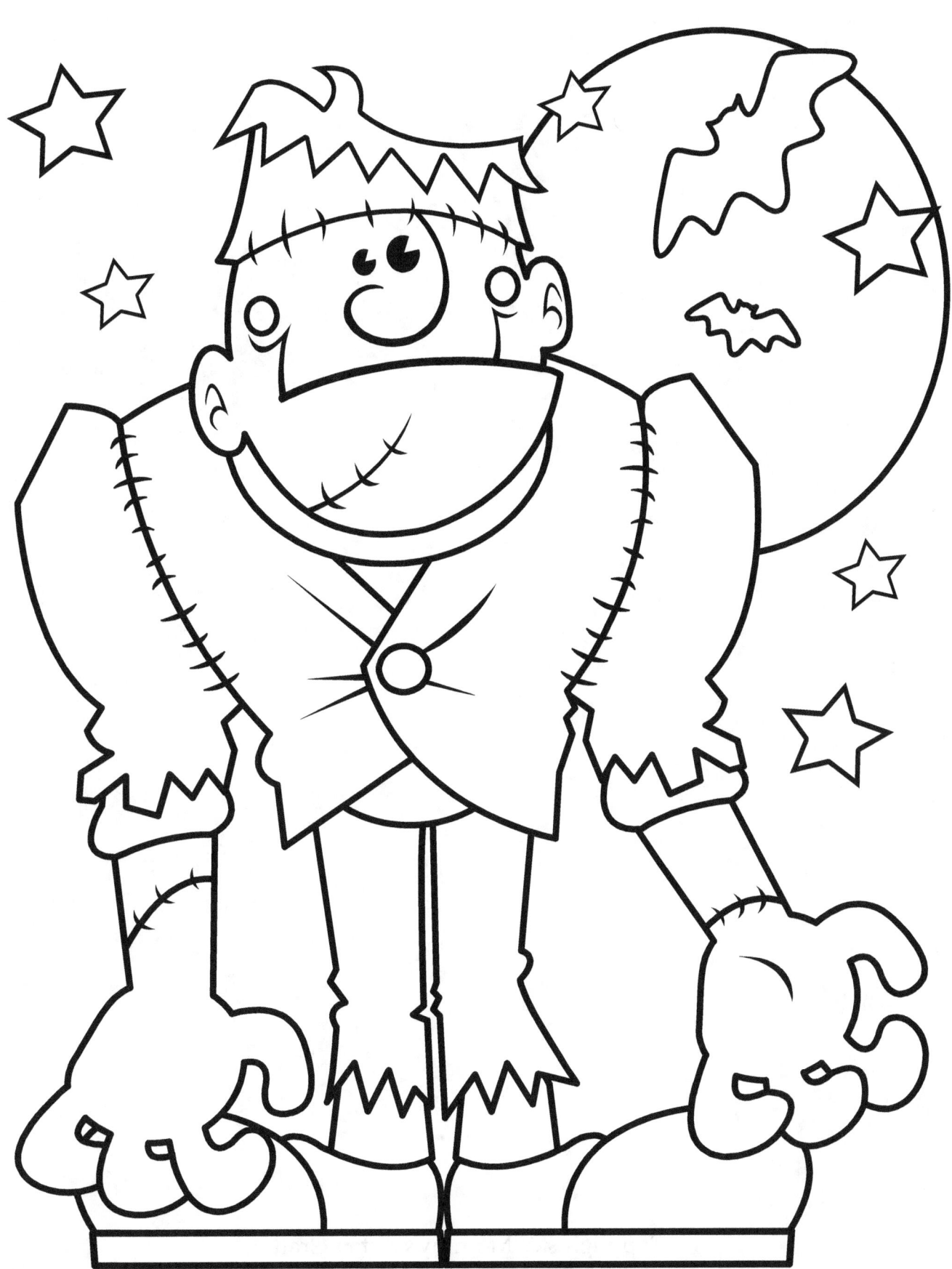

Copyrights @ Mommy's Art & Craft

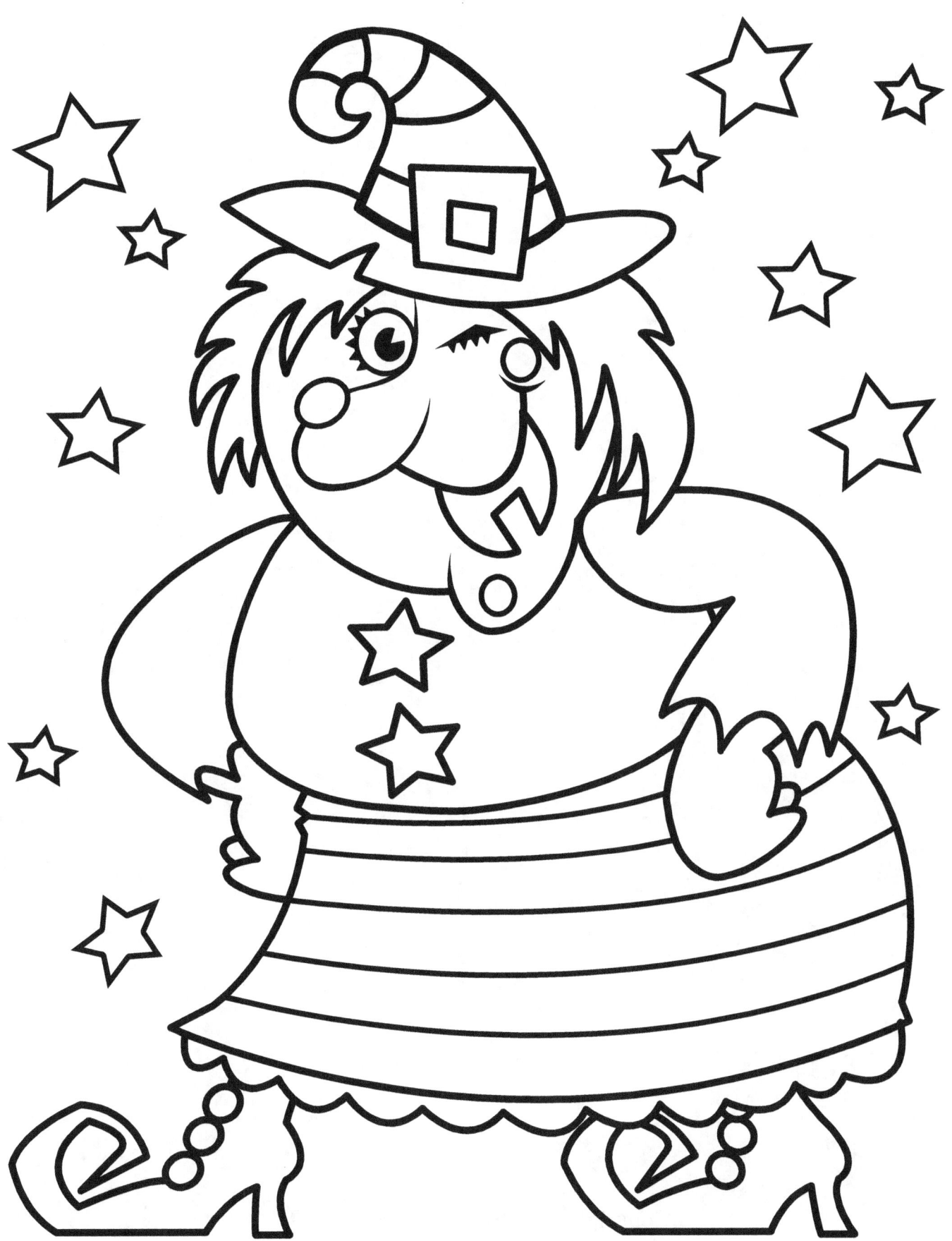

Copyrights @ Mommy's Art & Craft

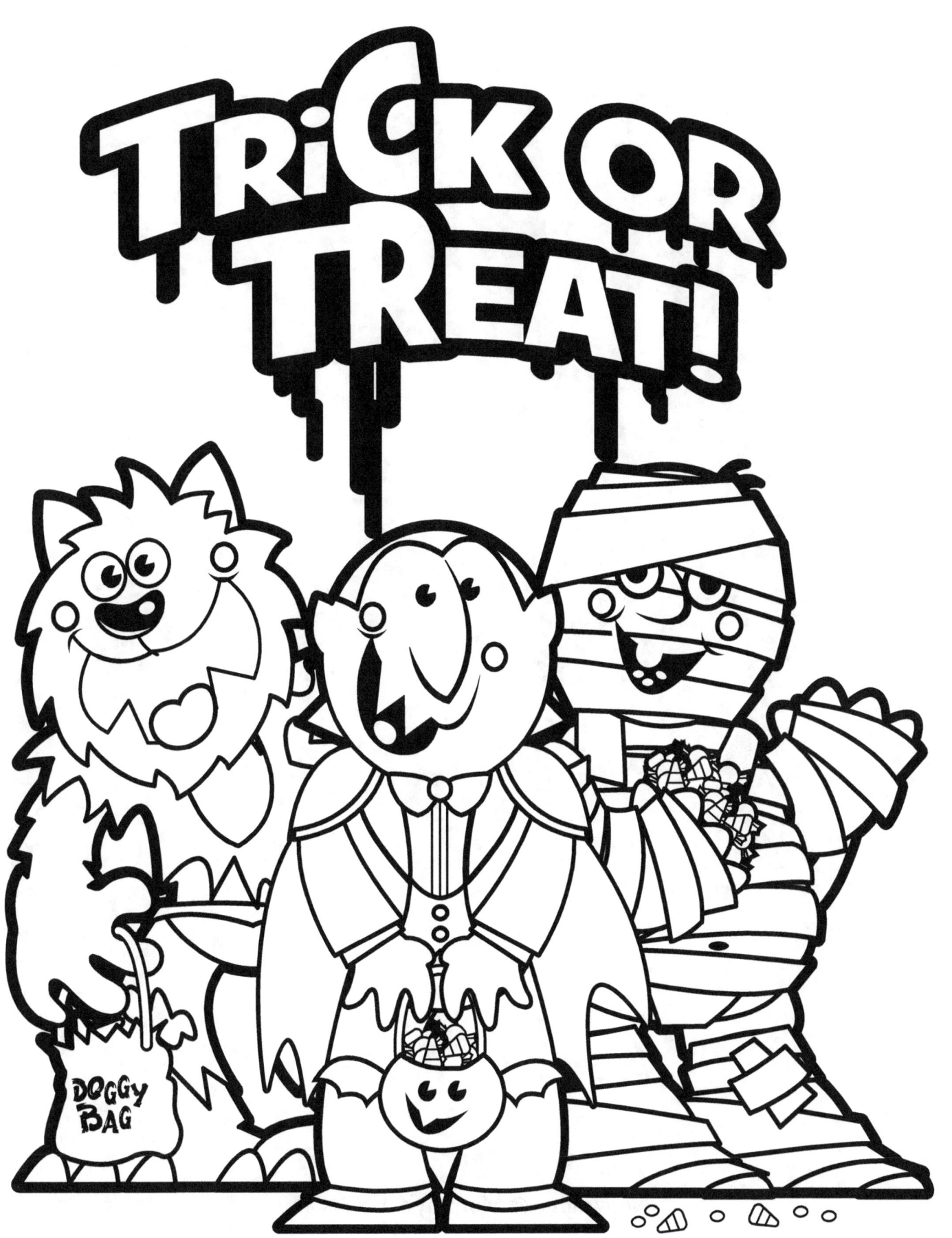

Copyrights @ Mommy's Art & Craft

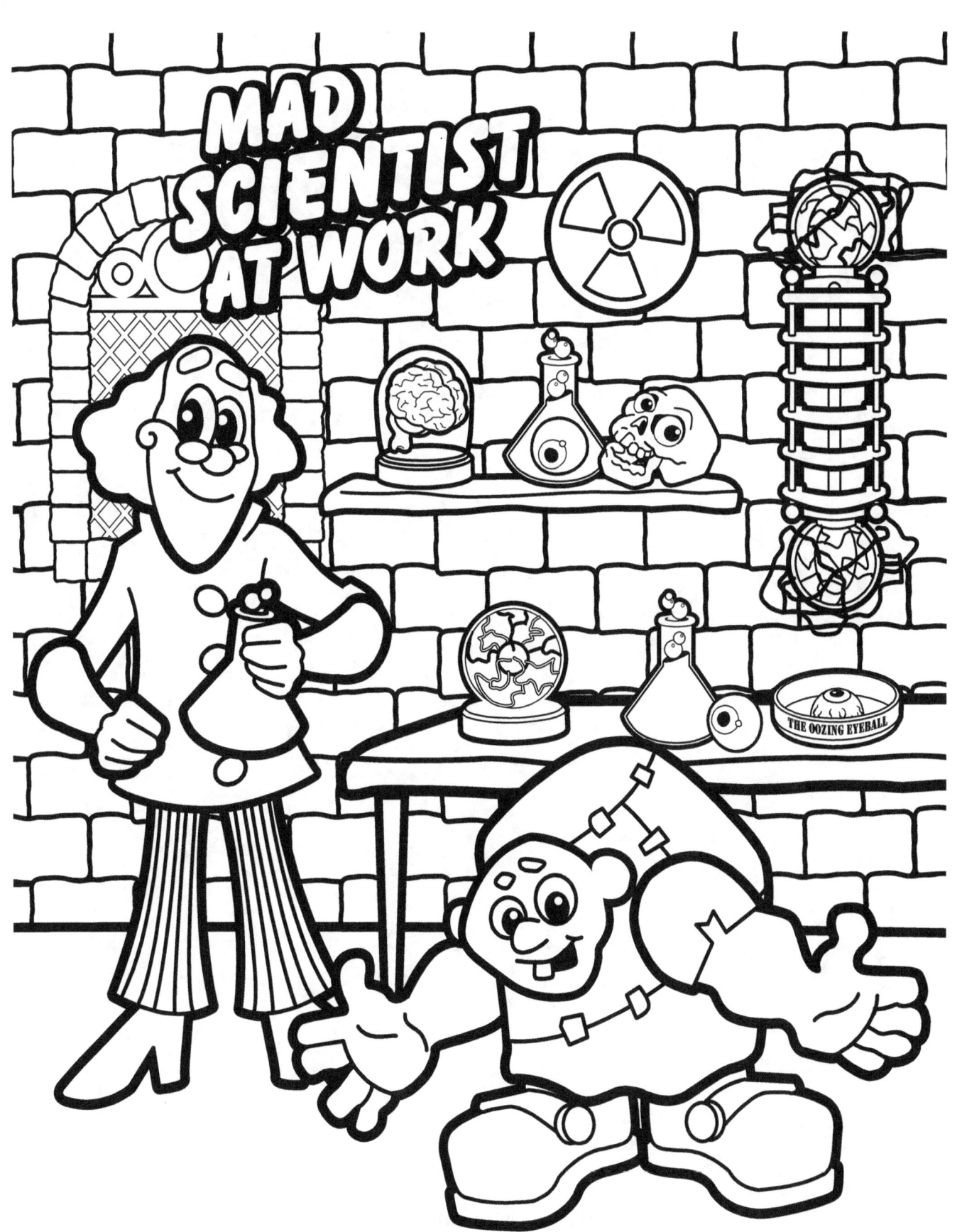

Copyrights @ Mommy's Art & Craft

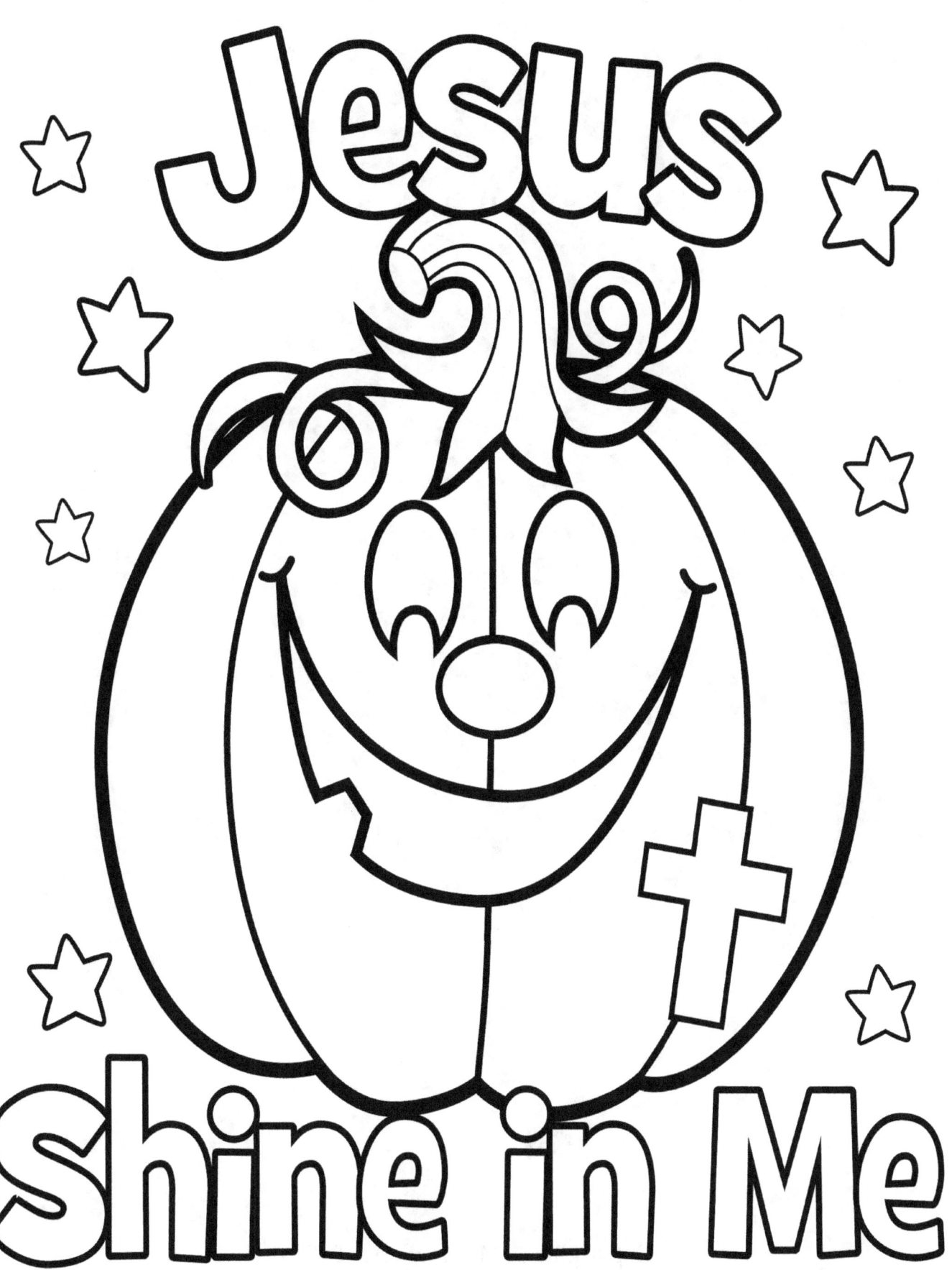

Copyrights @ Mommy's Art & Craft

www.ingramcontent.com/pod-product-compliance
Lightning Source LLC
Chambersburg PA
CBHW080815220526
45466CB00011BB/3568